I ♥ CUTE
COLORING

PSS!
PRICE STERN SLOAN
An Imprint of Penguin Random House

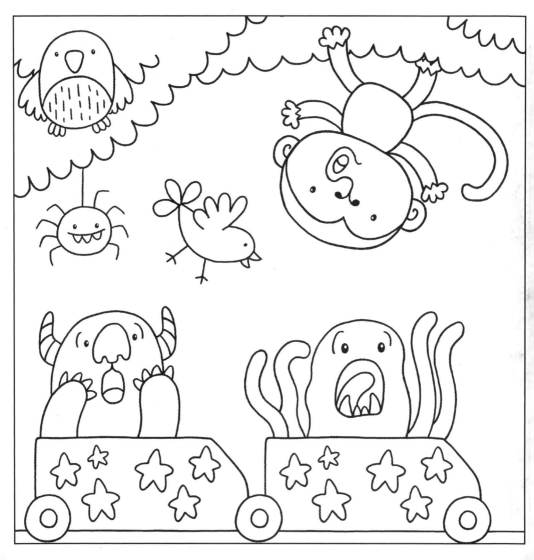

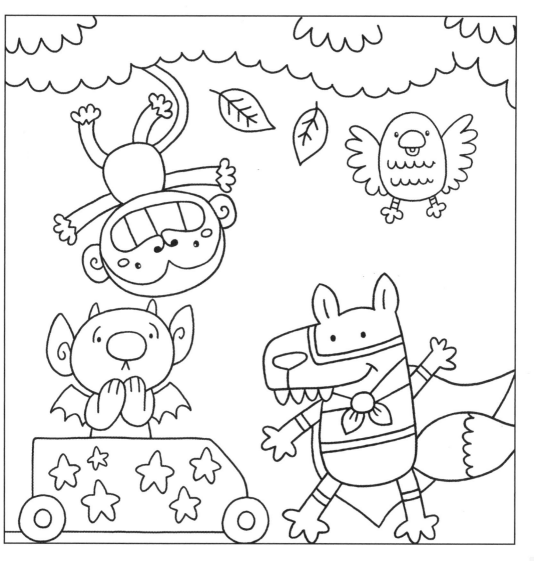

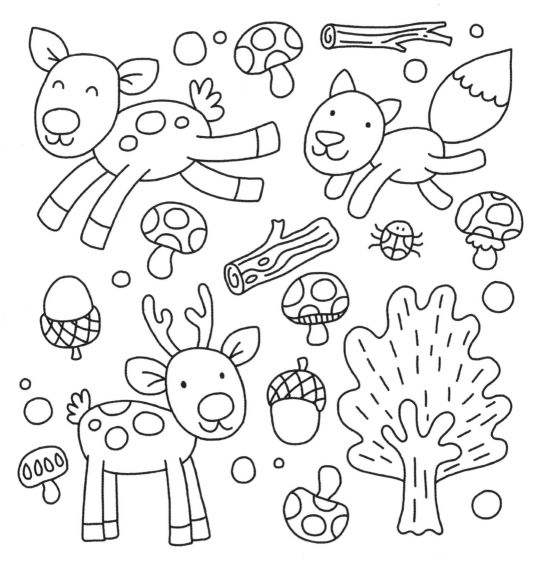

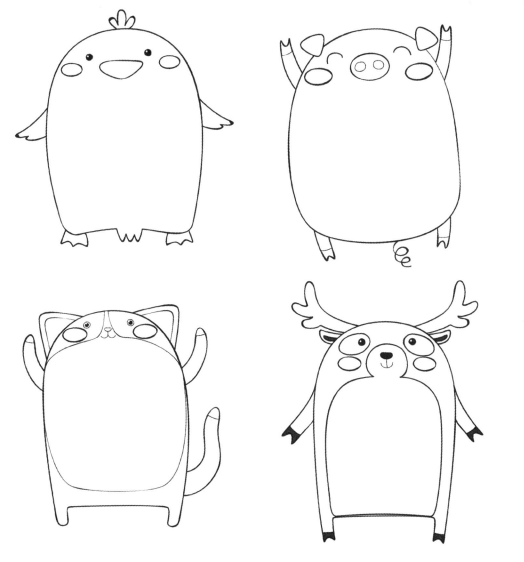

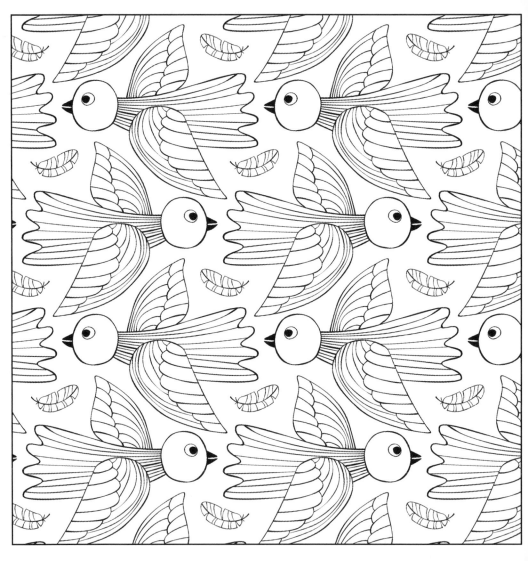

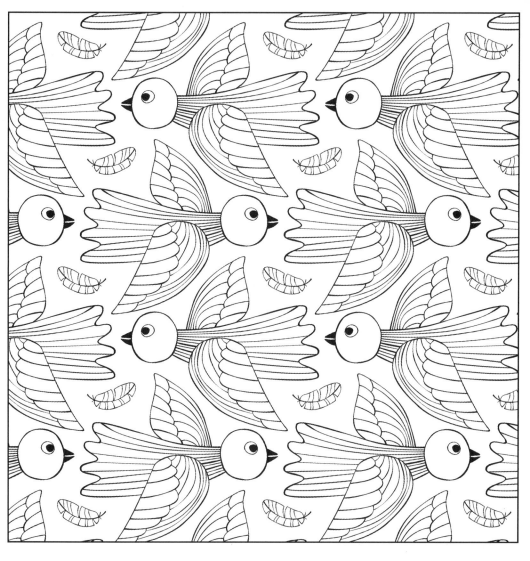

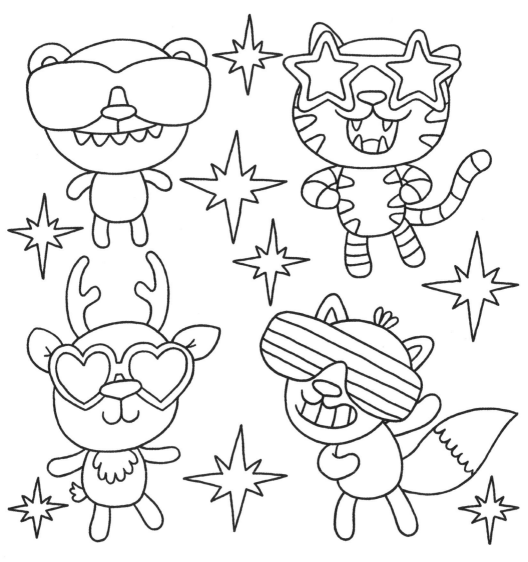

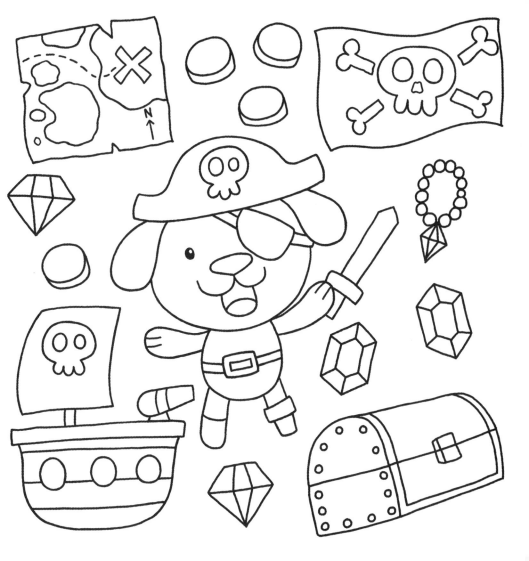

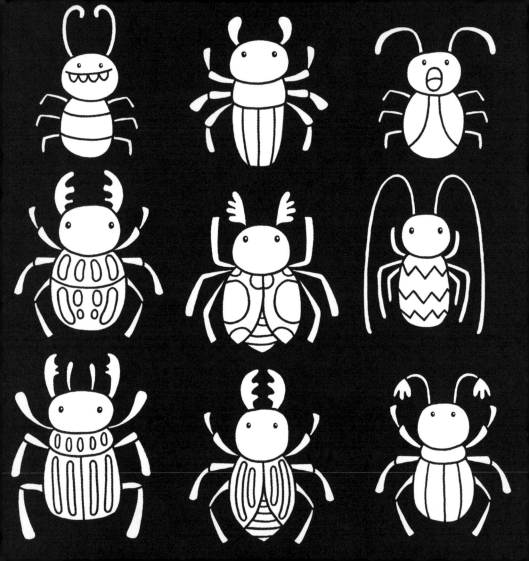

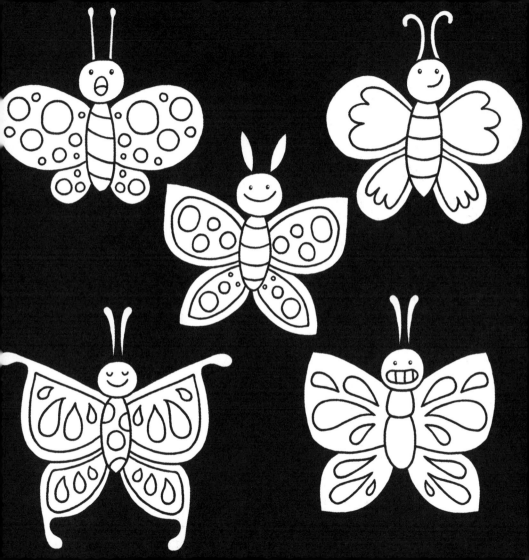

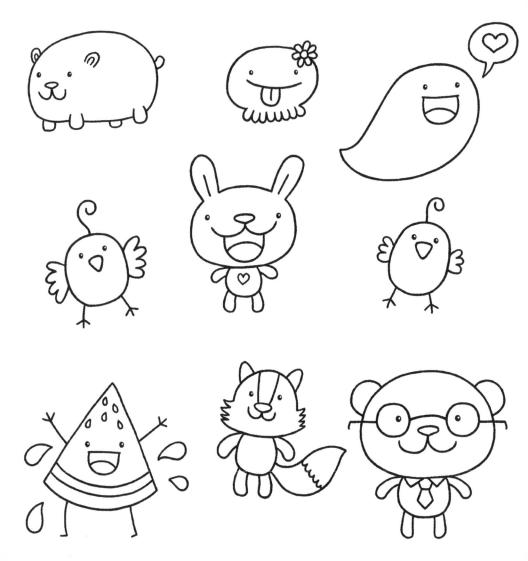

PRICE STERN SLOAN

Penguin Young Readers Group
An Imprint of Penguin Random House LLC

Penguin supports copyright. Copyright fuels creativity, encourages diverse voices, promotes free speech, and creates a vibrant culture. Thank you for buying an authorized edition of this book and for complying with copyright laws by not reproducing, scanning, or distributing any part of it in any form without permission. You are supporting writers and allowing Penguin to continue to publish books for every reader.

Illustrated by Jess Bradley, with additional material adapted from www.shutterstock.com. Copyright © 2015 by Buster Books. First published in Great Britain by Buster Books, an imprint of Michael O'Mara Books Limited. First published in the United States of America in 2015 by Price Stern Sloan, an imprint of Penguin Random House LLC, 345 Hudson Street, New York, New York 10014. *PSS!* is a registered trademark of Penguin Random House LLC.
Printed in Canada.

ISBN 978-0-399-54129-2 10 9 8 7 6 5 4 3 2